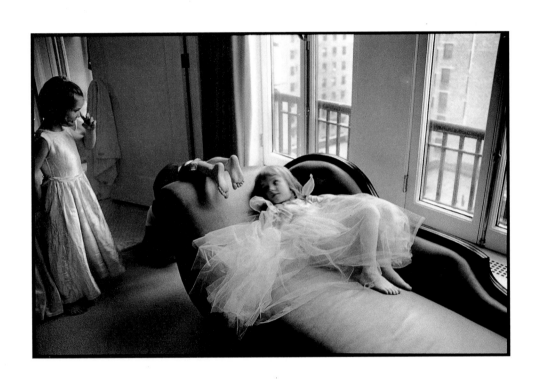

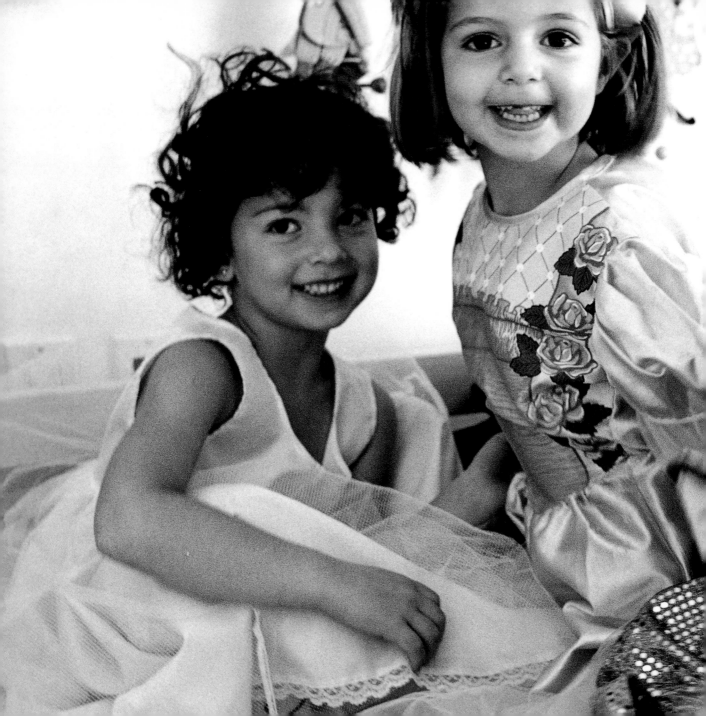

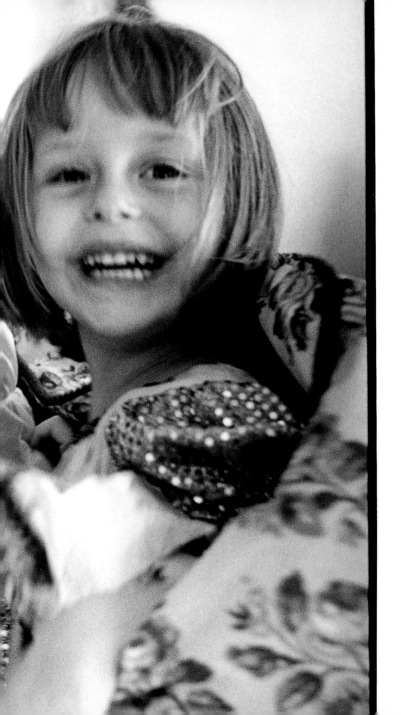

A CHILD'S
WORLD

LAURA STRAUS
AND THE EDITORS OF
REDBOOK

A Welcome Book

HEARST BOOKS
New York

Taking the time!

TO HEAR, TO SEE, AND TO CELEBRATE the feelings and thoughts of our children. That is the focus of this wondrous book of photographs by the young and gifted Laura Straus, the images graced by the words of the children she photographed.

Sometimes, we are just moving too fast as we race from one "significant" event to another, from one "important" task to another. Sometimes, we miss out on the "little" things. Sometimes, we are too pre-occupied to hear the amazing ways our children's minds are working. This book just reminds us to pause and look at their magical moments, their fantasies, and their joys. It quietly engages us and suggests that we take a minute to listen to their observations. Don't you completely identify with the child who was asked, "Where did you come from?" and answered, "I fell from a tree." "Where are you going," the interviewer continued. "Back up," she said. Oh, my goodness, I think I have to post that above my desk.

It's a magical book because a child's world is a magical place when you can let go and be there. Who but a little delicious kid could describe a giggle as "a wiggle" or "a kind of laugh like a hiccup." Who but a kid would admit, "I am not sure how clouds get formed. But, the clouds know how to do it, and that is the important thing." And they're right. It is the important thing. They also have advice; "Listen to your brain. It has lots of information." And, in the simplest, most basic way, they remind us of how connected we all are, one to the other; "Are you a human being? I'm a human being. We must be related." If only we could retain that truth as we grow older and regard all humans as we do to our own family.

From Redbook's family to yours, we hope that you are touched by as much pride and love by this profound and joyous little book as we are.

Lesley Jane Seymour
Editor-in-Chief, *Redbook Magazine*

"They are the sons and daughters of Life's longing for itself."

—*The Prophet*, Kahlil Gibran

IT WAS A GRAY WINTER DAY. The photo shoot with three little girls didn't show much promise. The light was poor, the apartment dark. Pulling antique dresses from a trunk, they draped themselves in satin and taffeta. They danced, whirling around the apartment, and suddenly their life, intensity, and playfulness made me forget the rain and cold. That January afternoon, as Elizabeth and her friends cavorted before my lens, *A Child's World* was born. Whether at the beach, in city apartments, sun-dappled forests, open fields, or suburban backyards, the children included on the pages of this book welcomed me into their worlds. In front of my camera, some of them are wild-eyed and restive; others are intent upon forming relationships with their friends, their parents, and even, graciously, their photographer.

THERE WERE PLENTY OF TIMES when I wanted to stay, to be an ongoing part of the lives of these incredible children. I wanted to see

them in a week, in a year, as teenagers, and as adults. Take three-year-old Jorden and Alessandra, holding hands as though they have been married for years. Or Isabelle, who taught me to speak with children the way you would with a wise woman. Or Teddy and Joseph, who would poke the lens with curious fingers, only to run away when my face disappeared behind the camera. Their spontaneity sometimes made me wistful, but most often it filled me with energy. I shared the excitement of bouncing on a trampoline with Orphea and Cella and the sheer joy of running down a beach, breathless with expectation and joy, with Quinn, Rebecca, and Danielle. Just watching Nico sleep, dreaming and enchanted, or Isabelle and Lena dressing up as princesses, awakened in me the dormant rules of child play. Their imaginations enlivened me and brought me not back in time but forward, to a world now suffused with more energy, more life, more possibilities.

INSIGHT INTO THESE SECRETS OF YOUTH—and the chance to bring this gift into my own life—is the reason why this project will never end for me. To capture the lives of these rambunctious, curious, cranky, honest children has been a great adventure, and I welcome you to share it with me in *A Child's World*.
 —Laura Straus

Where did you
come from?
I fell from
the tree.

Where are
you going?

MARTHA, AGE 6

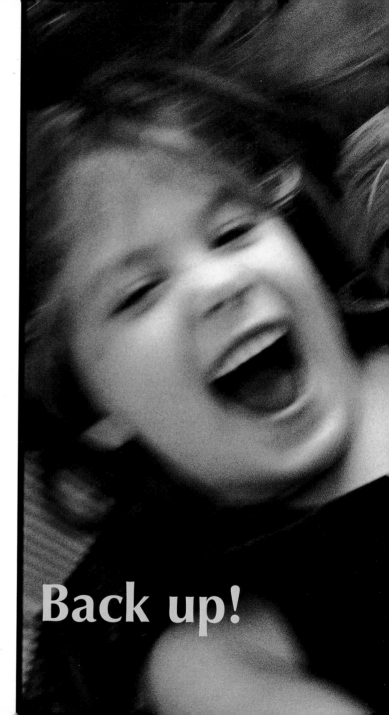

Back up!

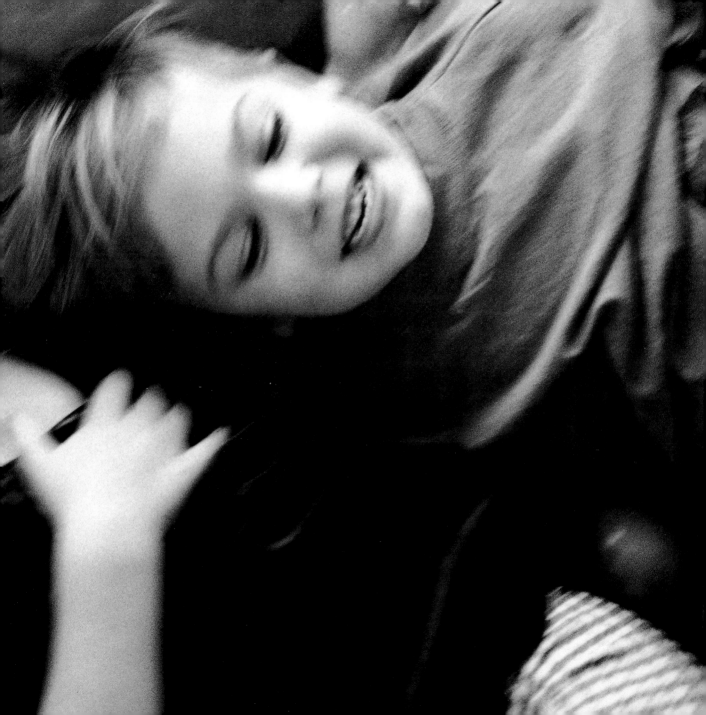

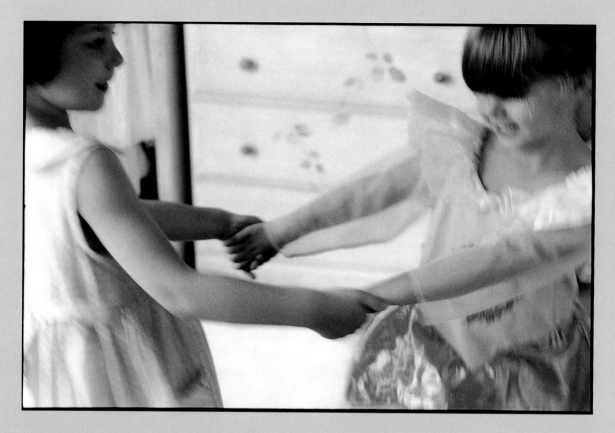

What is dancing?
**Something that keeps
you entertained at parties.**
BRENDAN, AGE 7

I dance because
it makes my feet tickle.
LAURIE, AGE 5

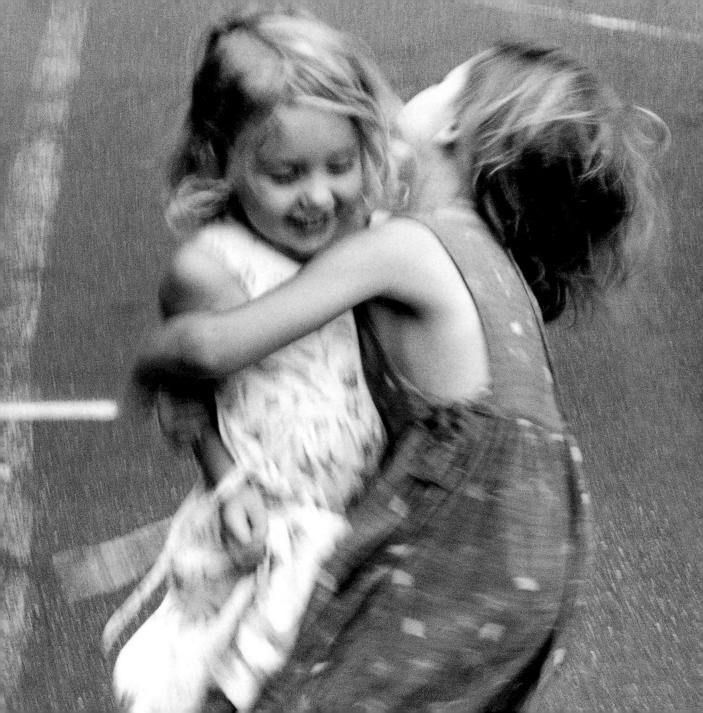

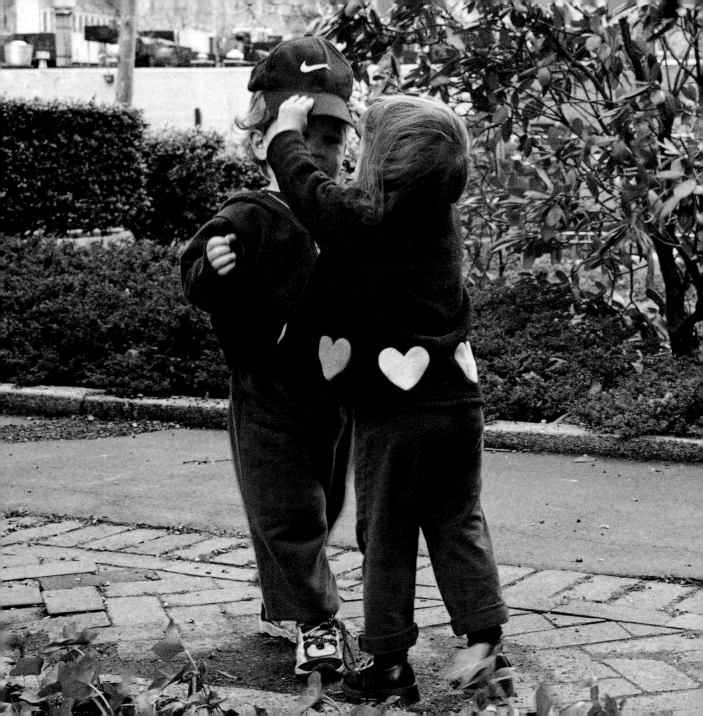

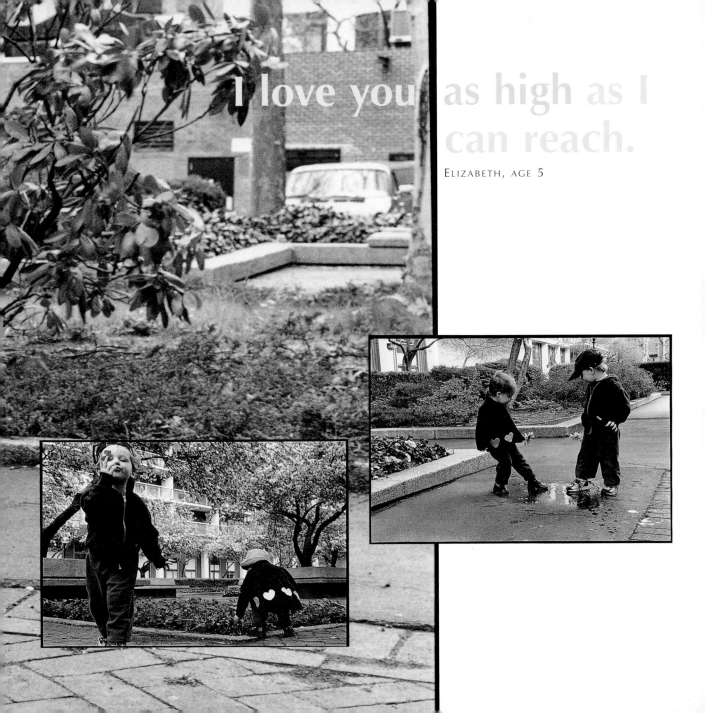

I love you as high as I can reach.

ELIZABETH, AGE 5

She's the one who talks in her
sleep, not me. I just answer her.

TAMARA, AGE 5

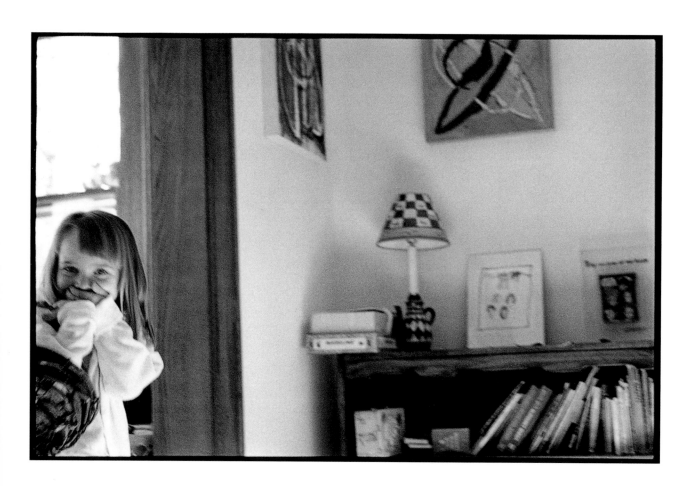

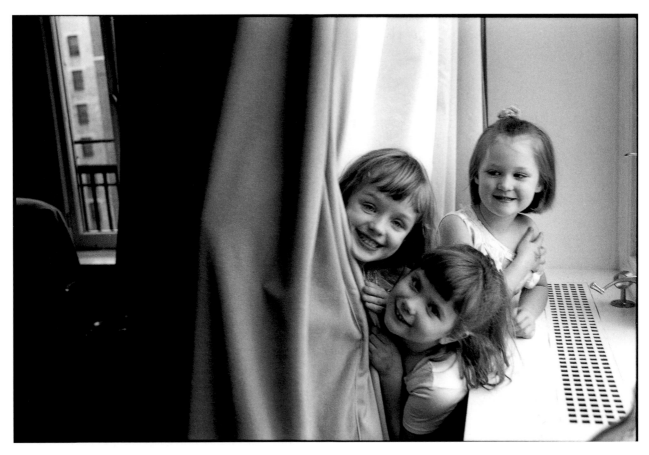

What's the best place in the whole world?
 Tanya's house.
Why?
 Because she has a wishing stone.
What's a wishing stone?
 That's where we wish.

What do you wish for?
 I wish that she would be
 my best friend forever.

SANDRA, AGE 5

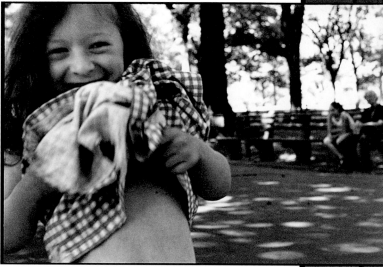

What is a giggle?
A laugh.

RYAN, AGE 5

A kind of laugh
like a hiccup.

BRENDAN, AGE 7

Is a wiggle.
A giggle is made of corn.

MANON, AGE 4

A giggle is a giggle.

WILLEM, AGE 8

A giggle is a happy laugh.

RORY, AGE 10

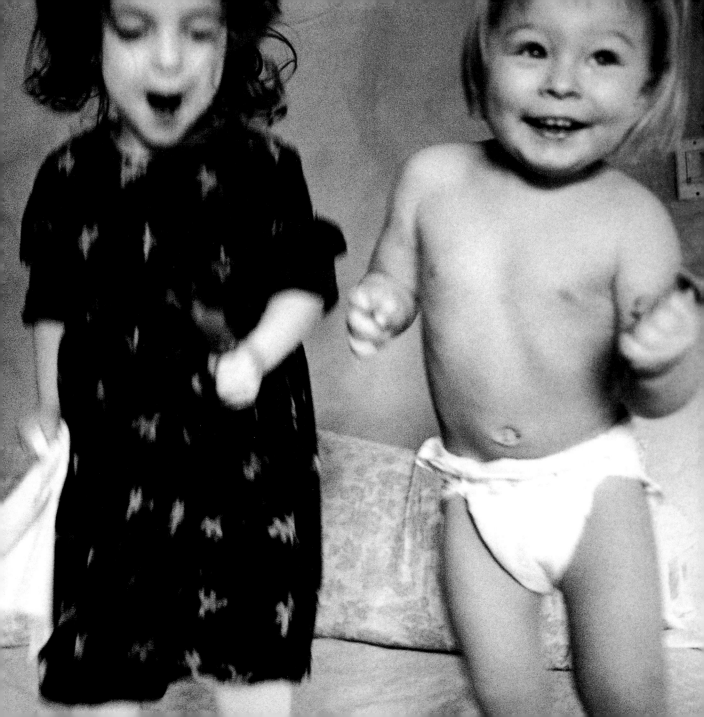

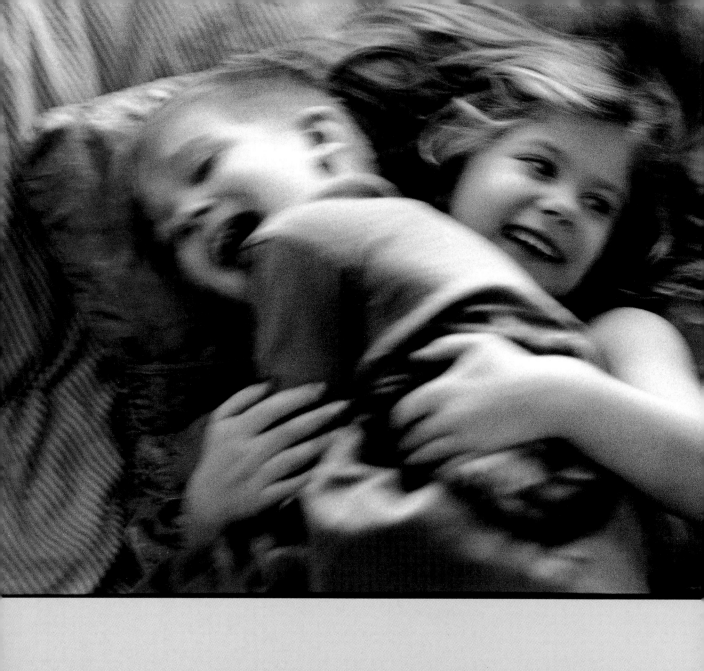

There are no bad guys in my family. There's no such things as a monster. They don't have keys.

GILLIAN, AGE 3

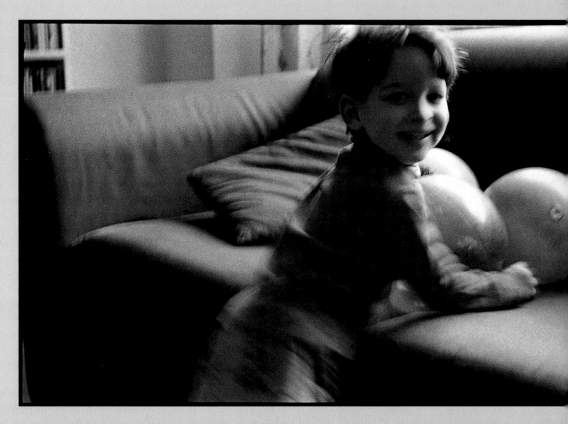

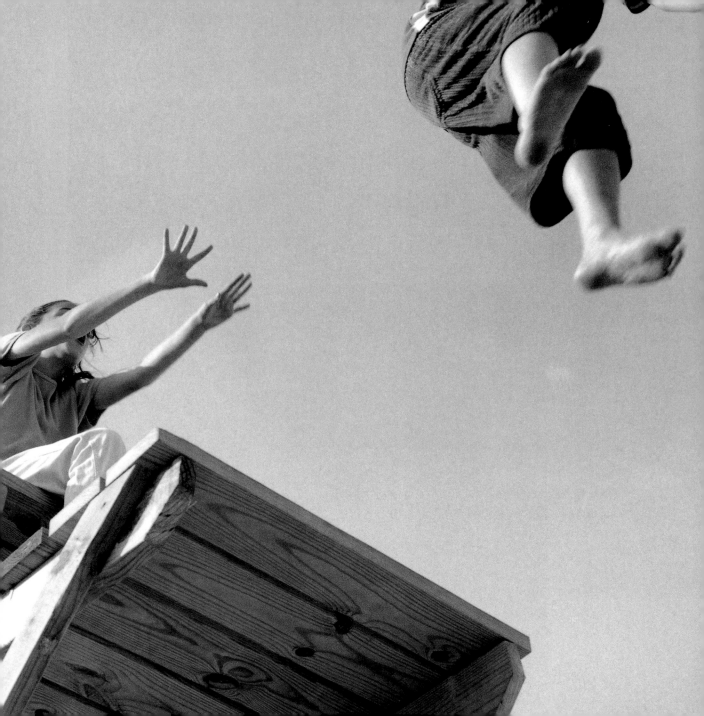

I can't keep my eyes on you,
you make me dizzy.
Then close your eyes
when you look!

BROOKE, AGE 4

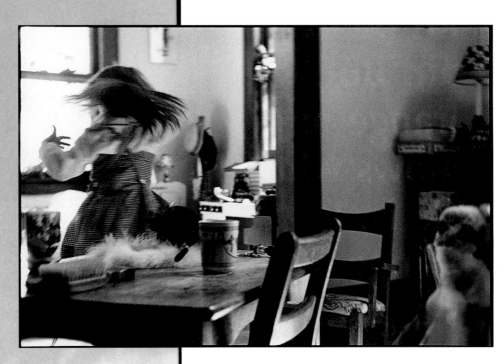

The colors don't know who they are. They're not being fair. But, the orange one knows who she is. The orange one is a girl.

GILLIAN, AGE 3

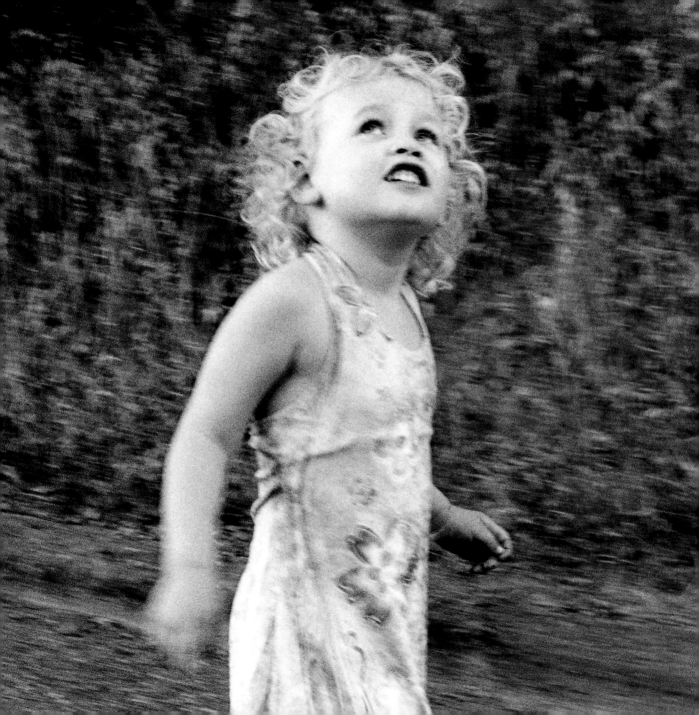

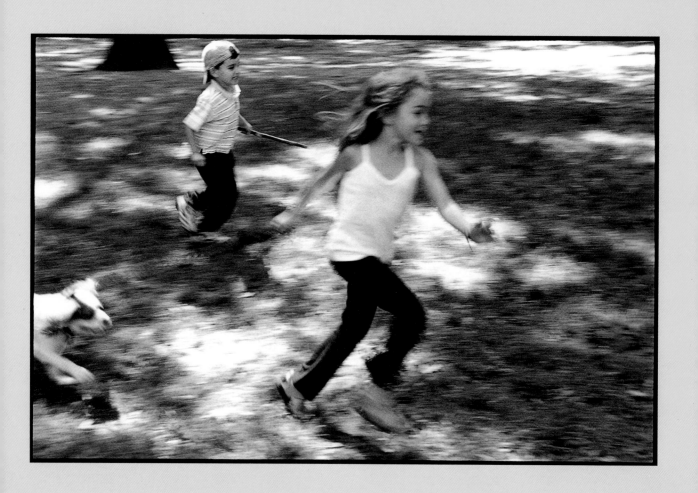

Air is wind,

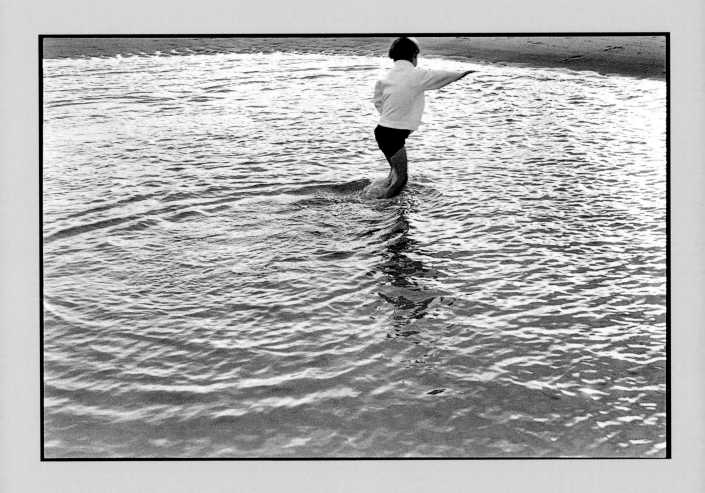

and the shadows make you cool.

Manon, age 4

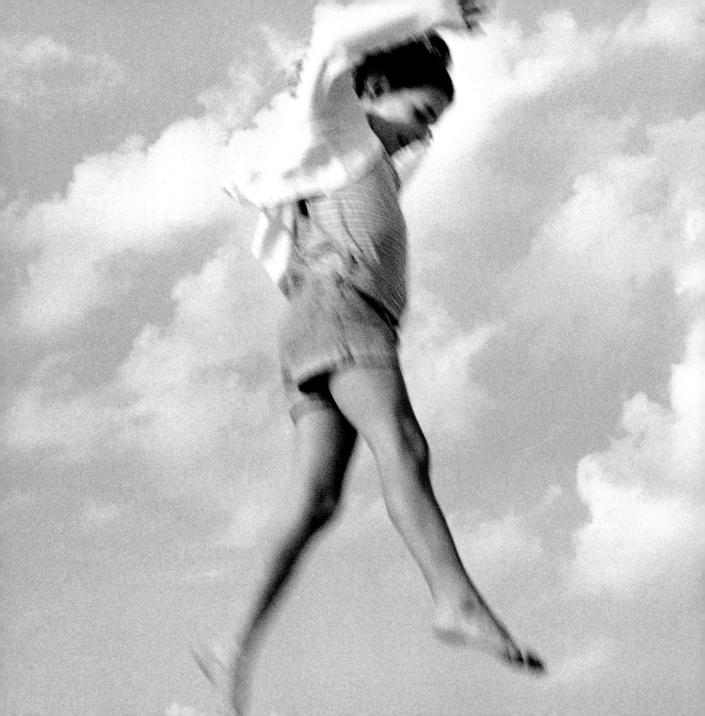

I am a cloud in the sky
and I like to fly.

RORY, AGE 10

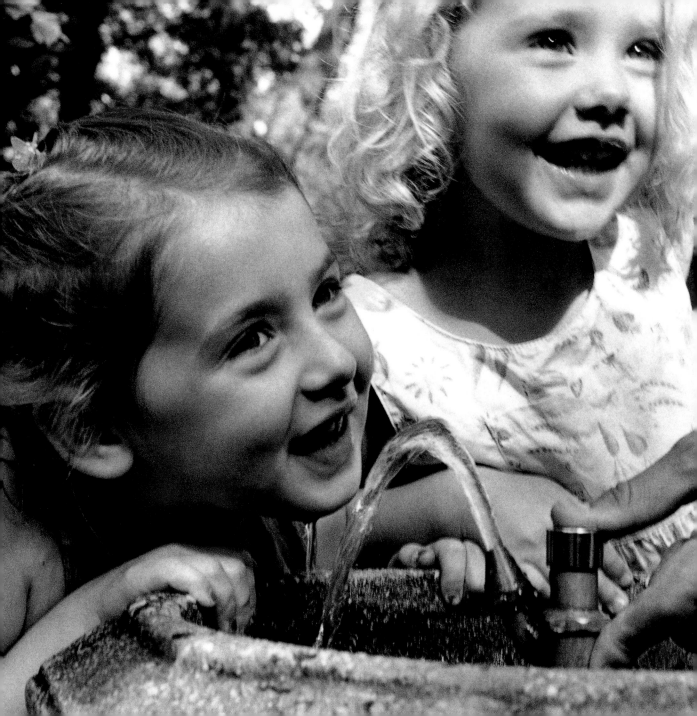

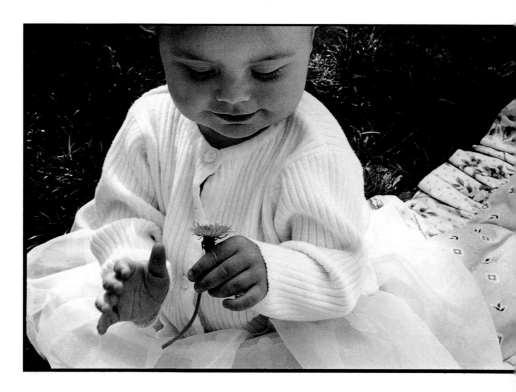

Do you ever feel like
you have only been here
for yesterday and today?

BEN, AGE 4

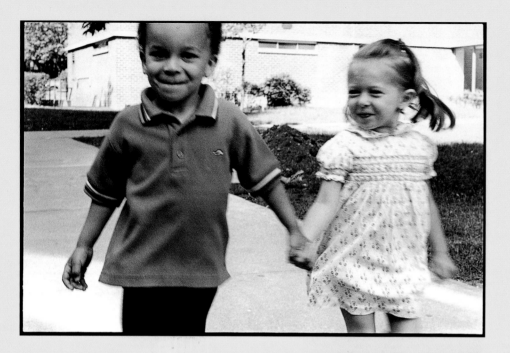

You have a
small hand . . .
like mine.

Matthew, age 4

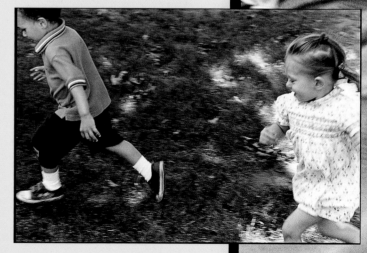

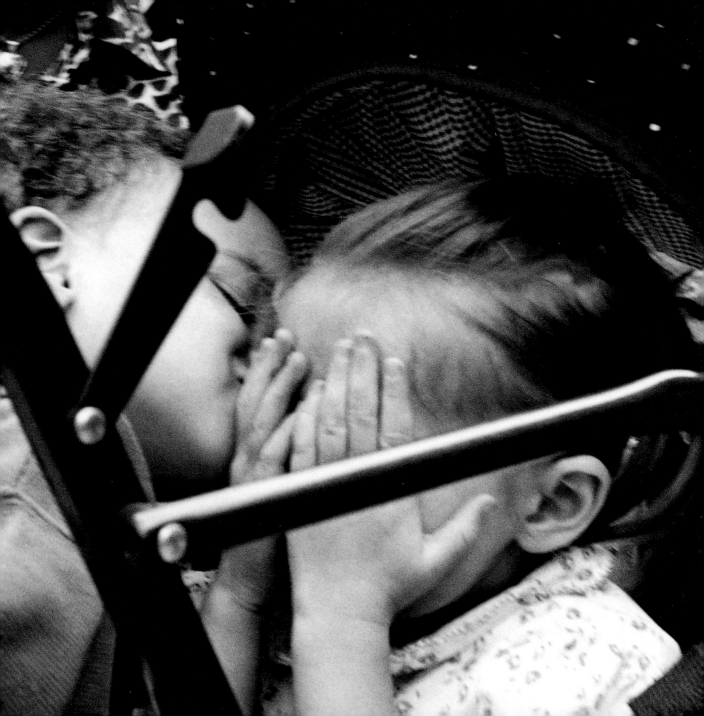

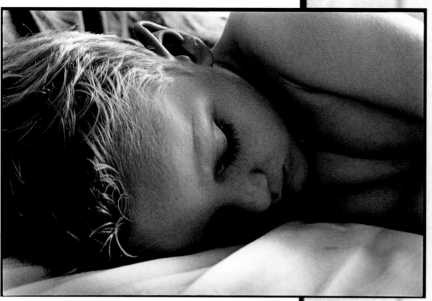

My favorite place in the
whole world is home
because I live here.

BRENDAN, AGE 7

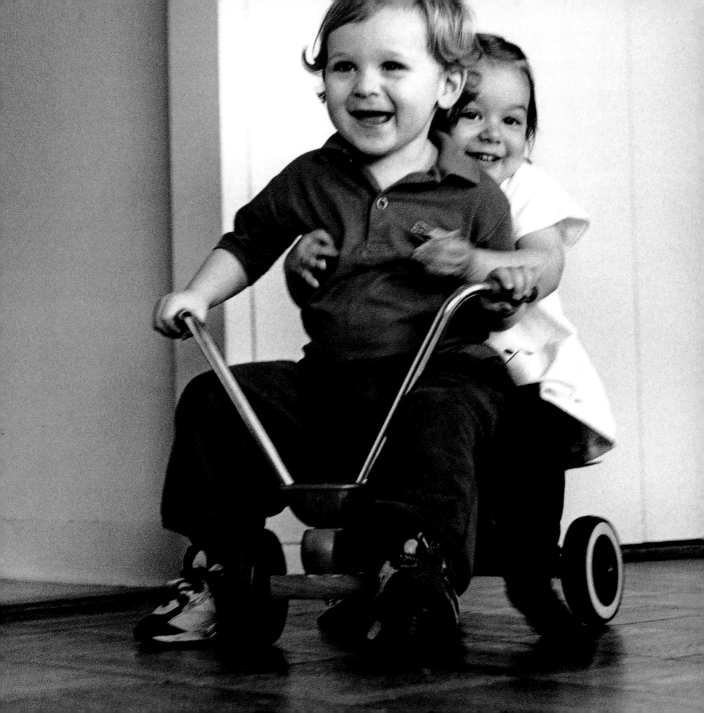

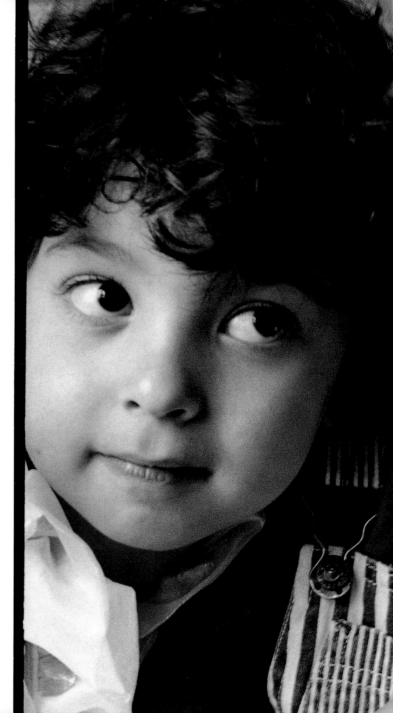

I was a
little scared.
But . . .
sometimes
I'm brave.

KATE, AGE 4

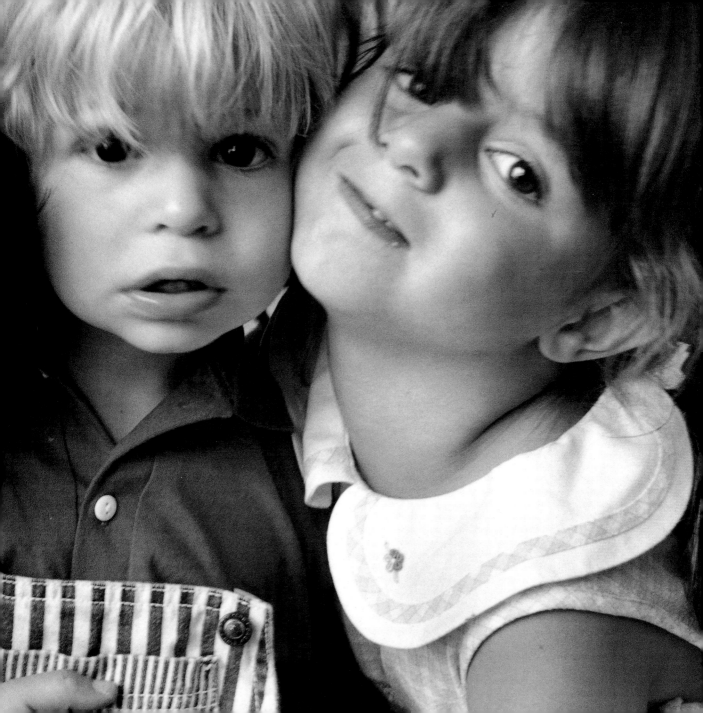

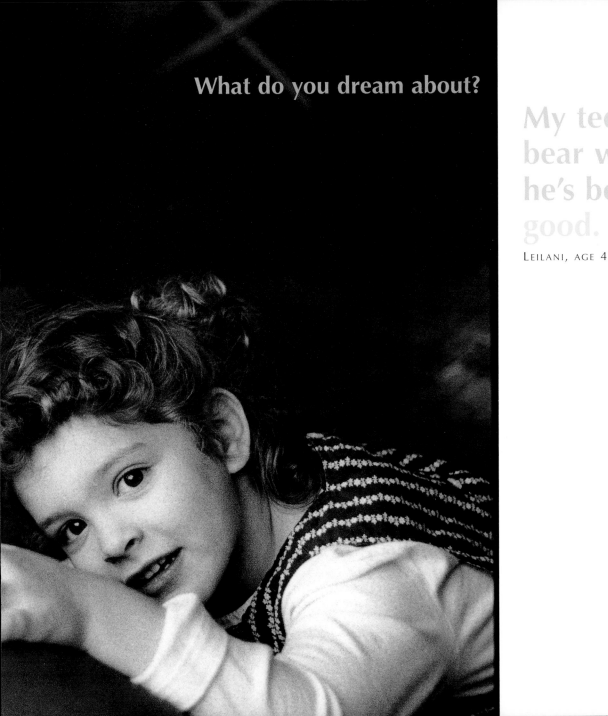

What do you dream about?

My teddy
bear when
he's being
good.

LEILANI, AGE 4

I dreamed about dancing princesses.
That's great. How wonderful!
(Sigh). . .I don't like dancing princesses.
CHI CHI, AGE 3

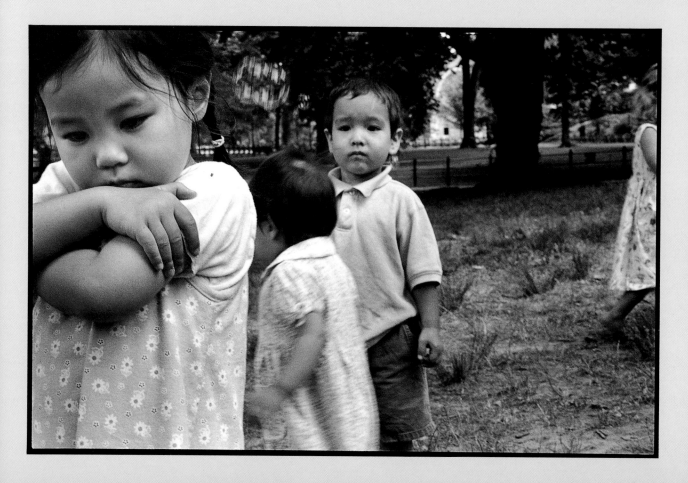

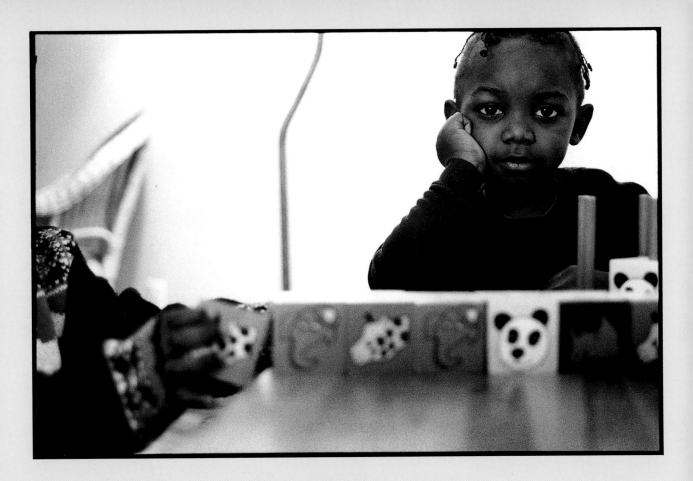

The sun goes up, the moon goes down,
the moon goes up, the sun goes down.
The sun goes up, the moon goes down,
the moon goes up, the sun goes down.
Just like that. That's all!

EVE, AGE 3

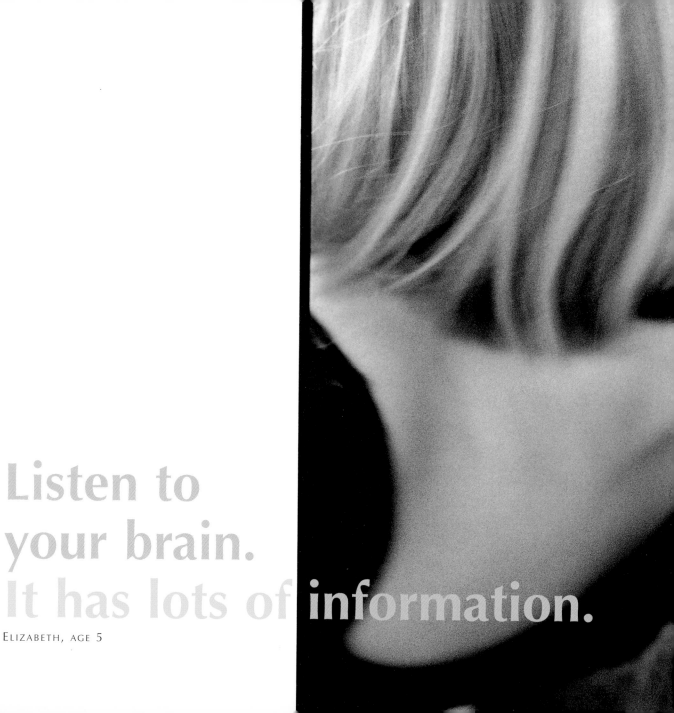

Listen to your brain. It has lots of information.

Elizabeth, age 5

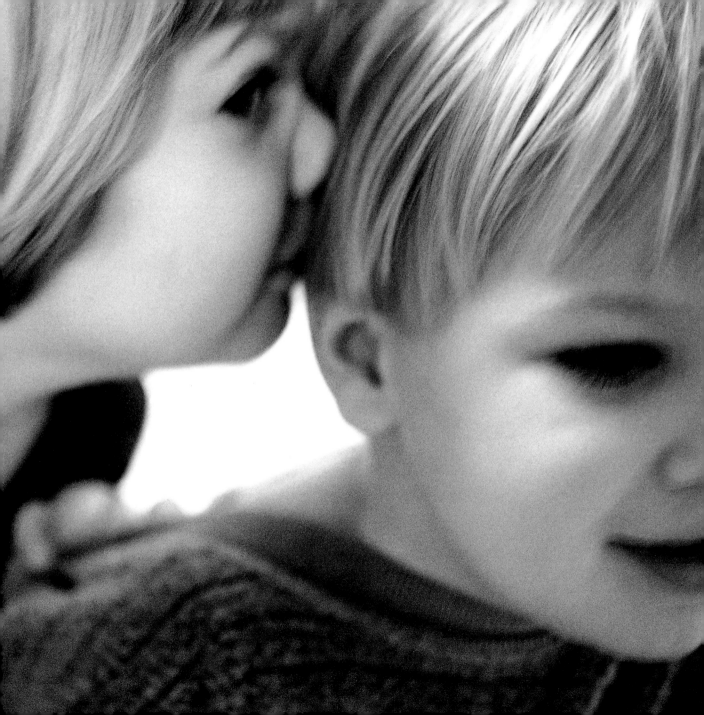

When you're young, your brain is small. When you get older your brain gets bigger and you get wrinkled.

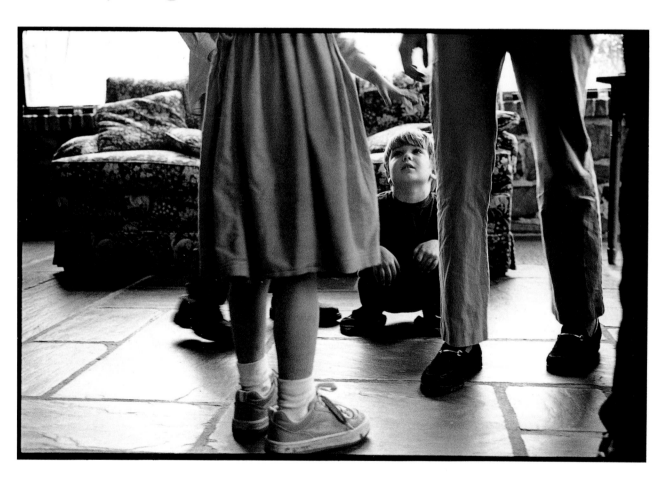

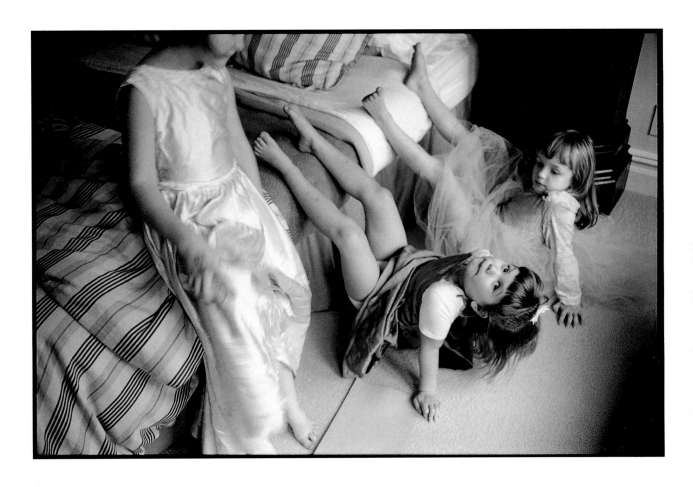

You can do a lot more when you're young,
like go to school and watch cartoons.

RORY, AGE 10

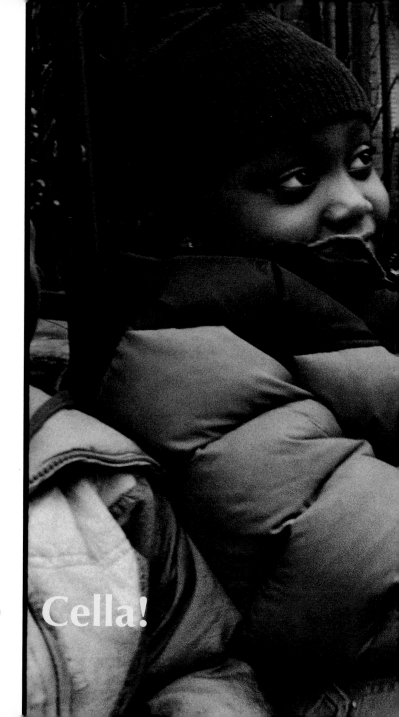

Do you want
to be beautiful
or smart?

I want to be Cella!

CELLA, AGE 3

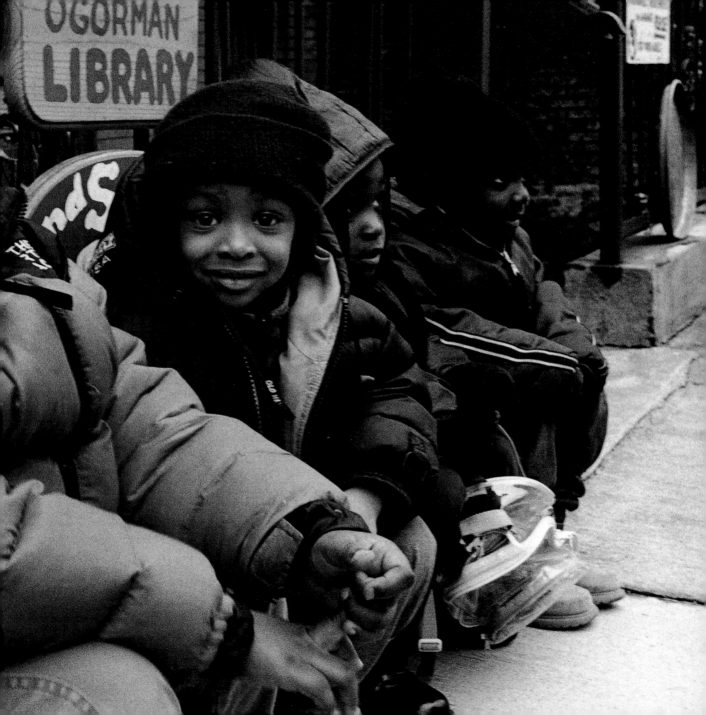

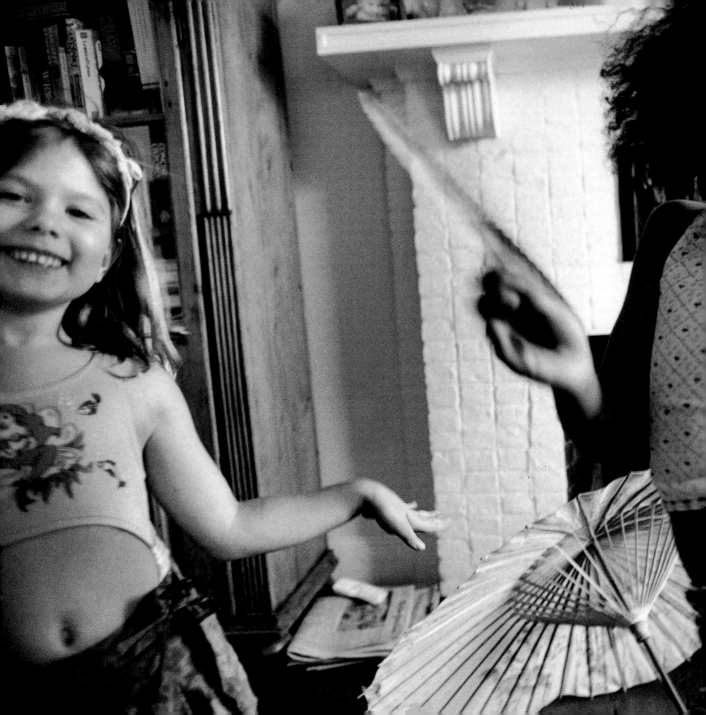

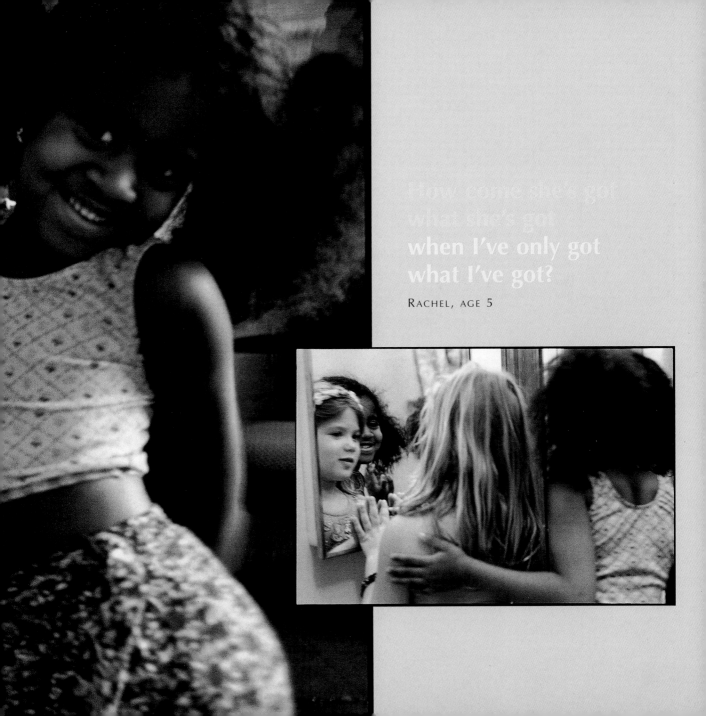

How come she's got
what she's got
when I've only got
what I've got?

RACHEL, AGE 5

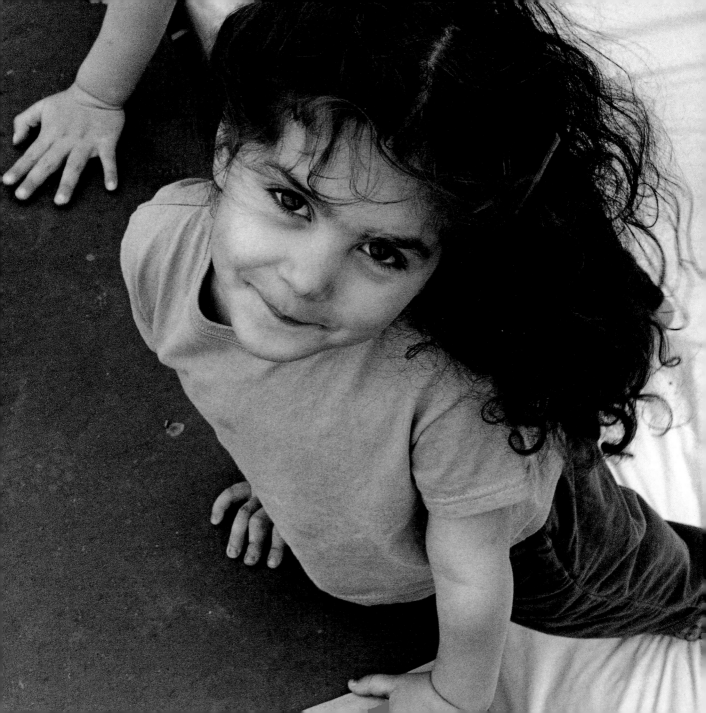

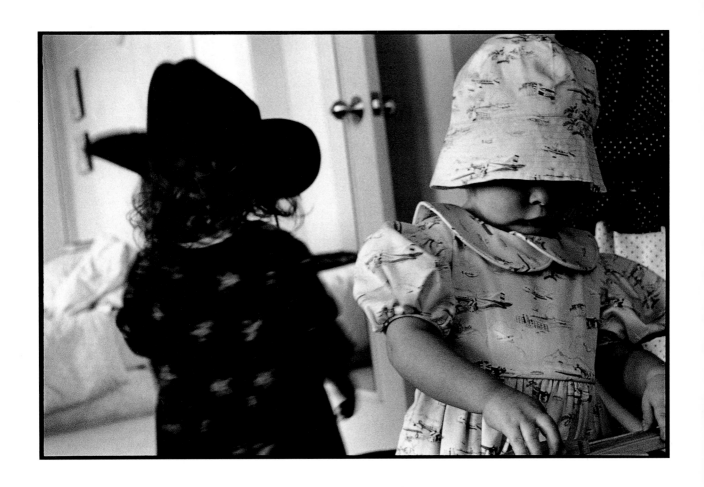

She's always saying that. Like the time when she
said that and then she wasn't even sorry. She says
that like she means it. But, I know she doesn't.
I love me anyway.

Martha, age 5

I like to dream about bad
things. Like Monsters. I go
into the dream and they
chase me but then I blink
and then I see another story.

MANON, AGE 4

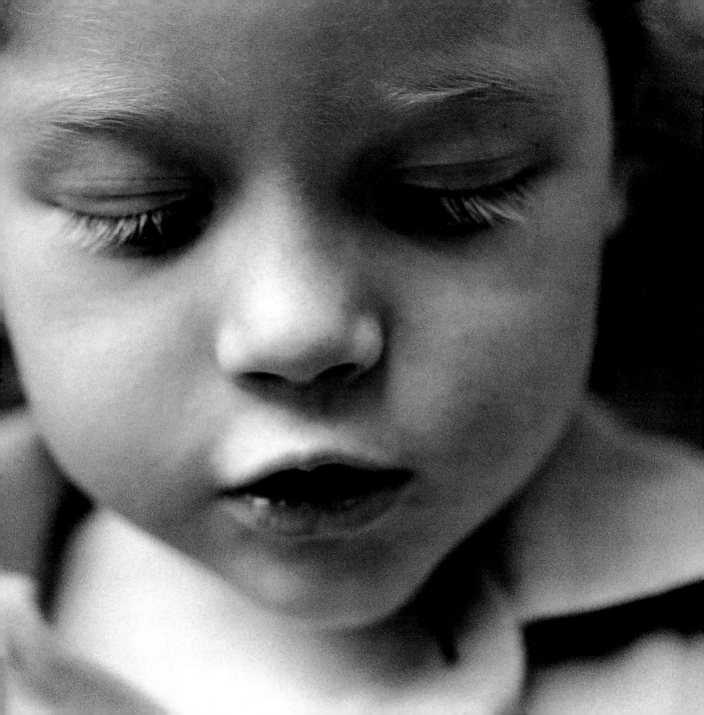

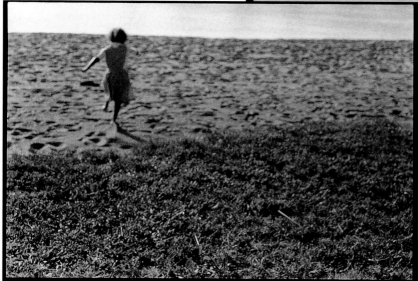

What is the sky made of?

Blue paint.

RYAN, AGE 5

Dust and clouds and paint.

BRENDAN, AGE 7

Water.

SOPHIA, AGE 2

Clouds and the sun and at
night the moon.

MANON, AGE 4

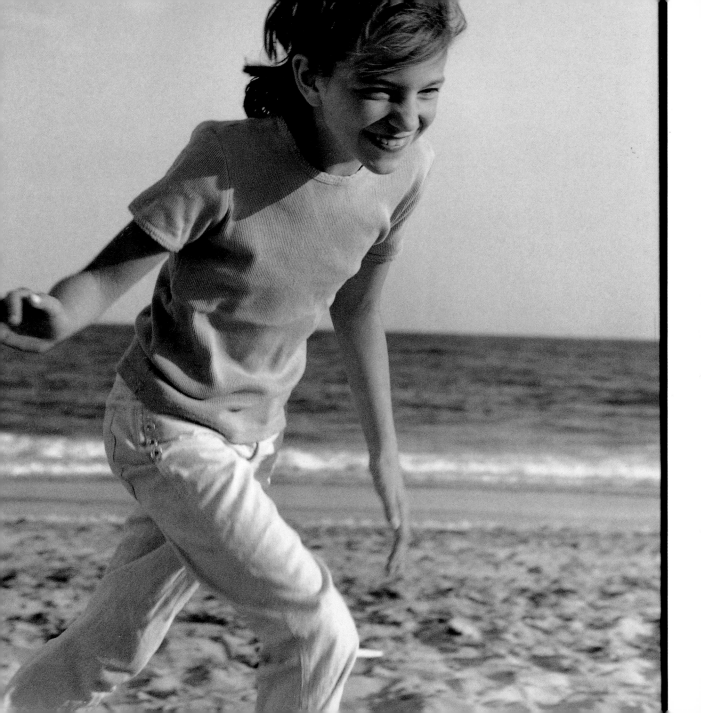

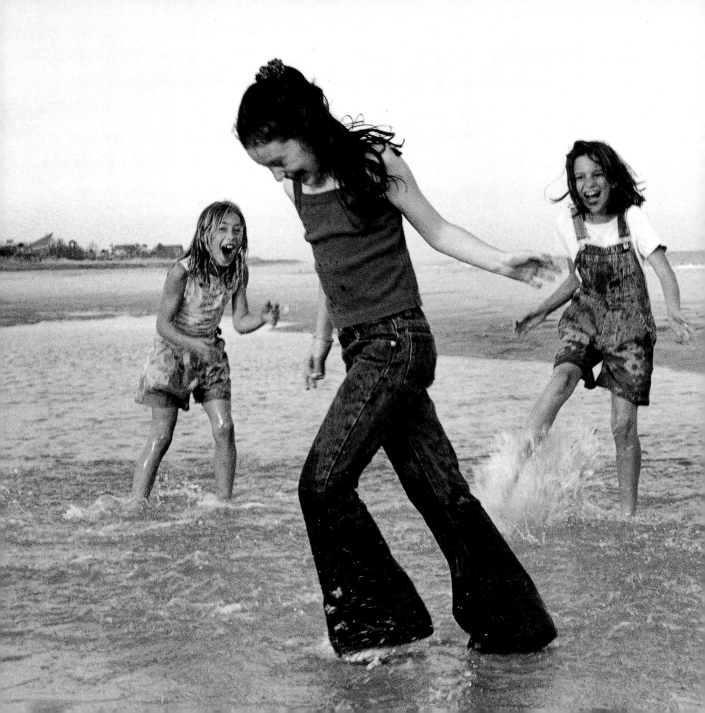

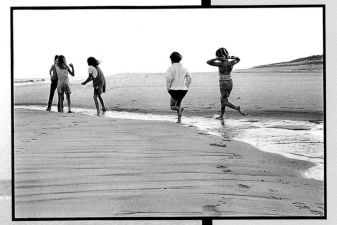

Sunshine is like
water on my tongue.

Jill, age 5

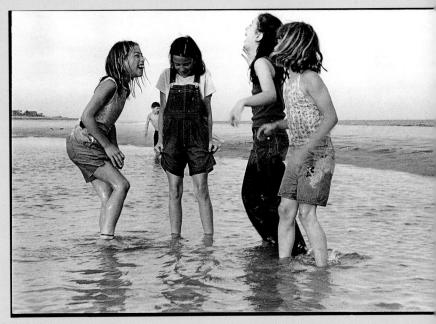

I am not
sure how
clouds get
formed. But
the clouds
know how
to do it, and
that is the
important
thing.

RACHEL, AGE 5

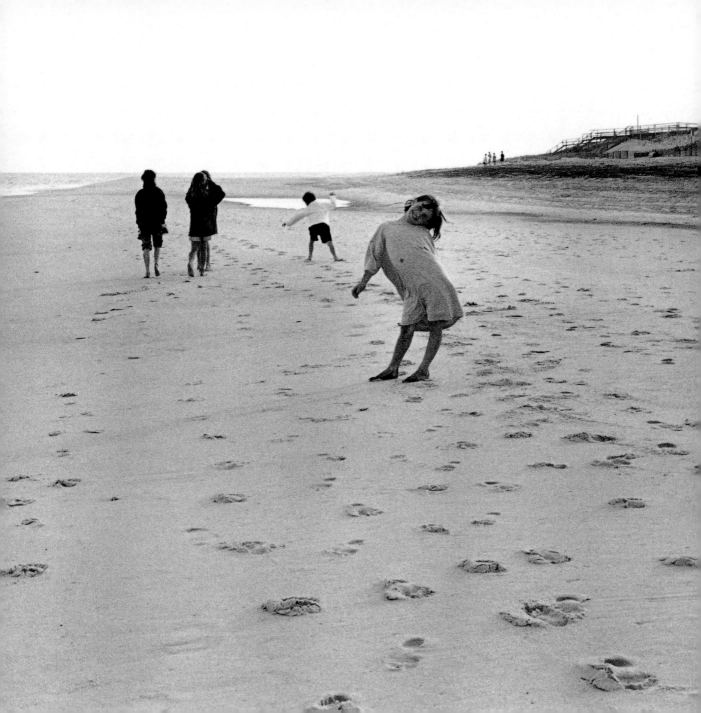

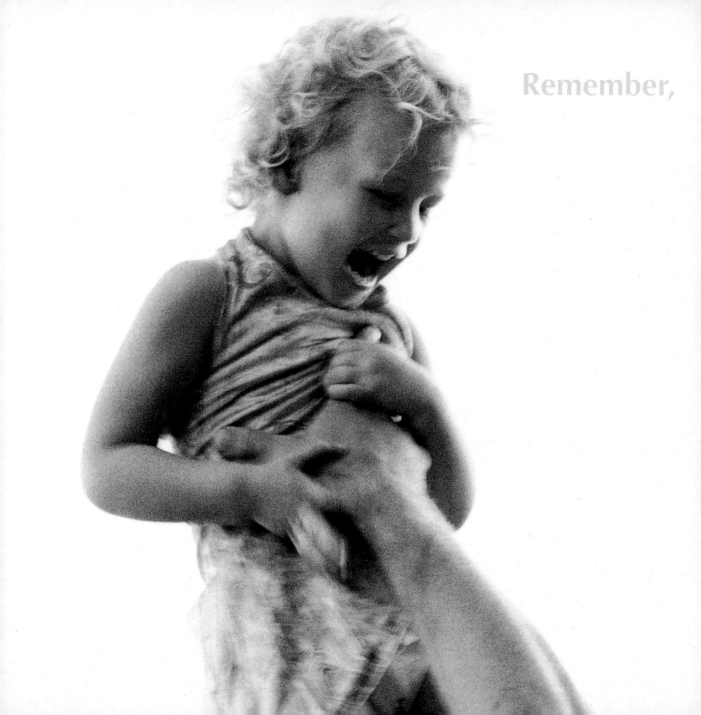

Remember,

you're never too old to hold
your father's hand.

MOLLY, AGE 4

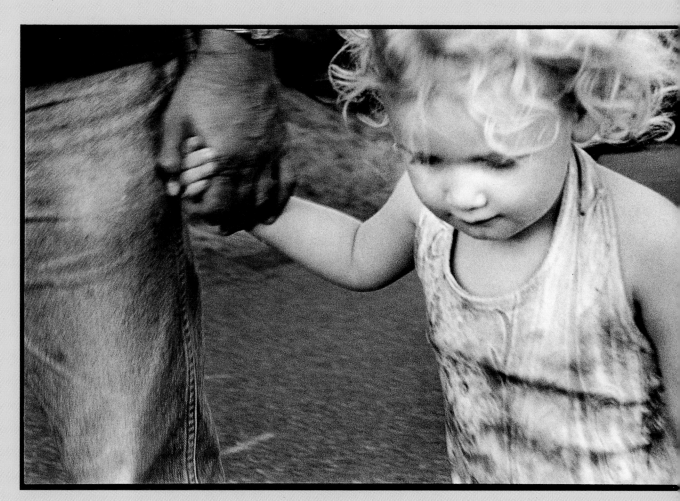

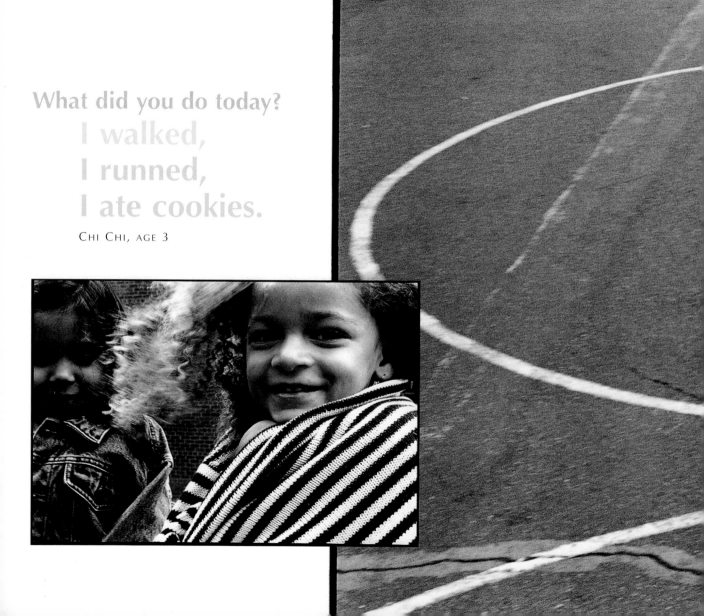

What did you do today?
I walked,
I runned,
I ate cookies.

CHI CHI, AGE 3

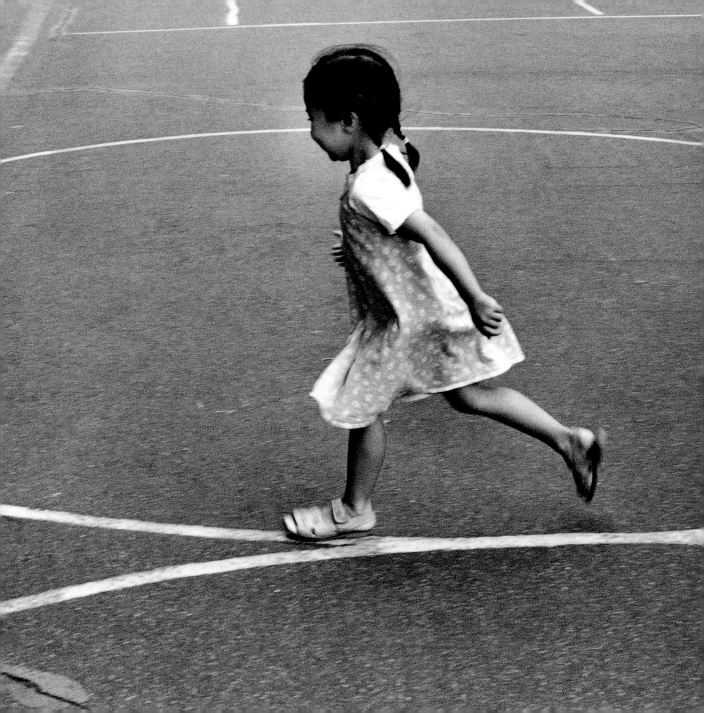

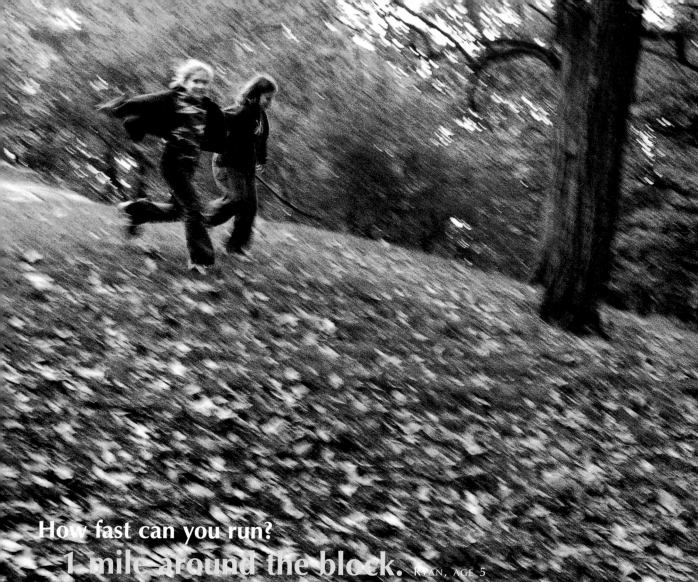

How fast can you run?
1 mile around the block. RYAN, AGE 5
About 99 miles an hour. BRENDAN, AGE 7
I can run faster than the wind. BENJAMIN, AGE 4

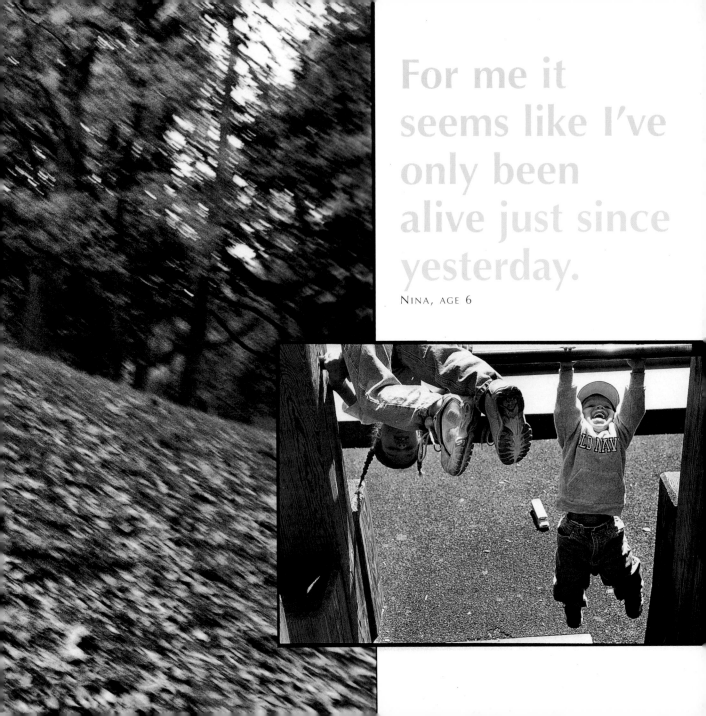

For me it seems like I've only been alive just since yesterday.

NINA, AGE 6

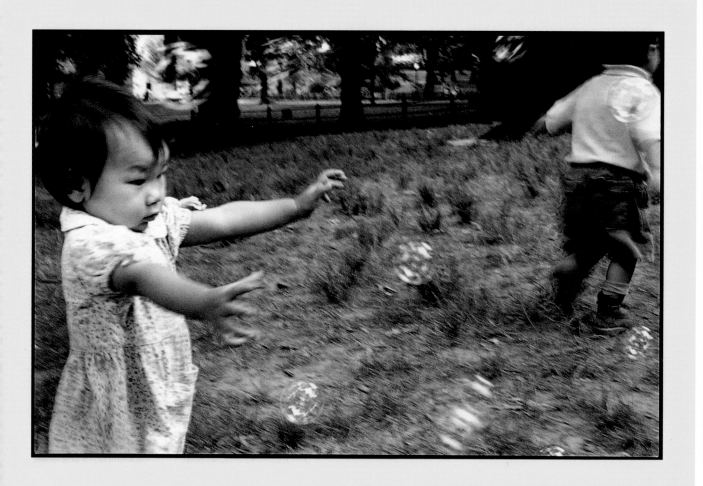

What did you dream about last night?

Trucks.

KOJIN, AGE 2

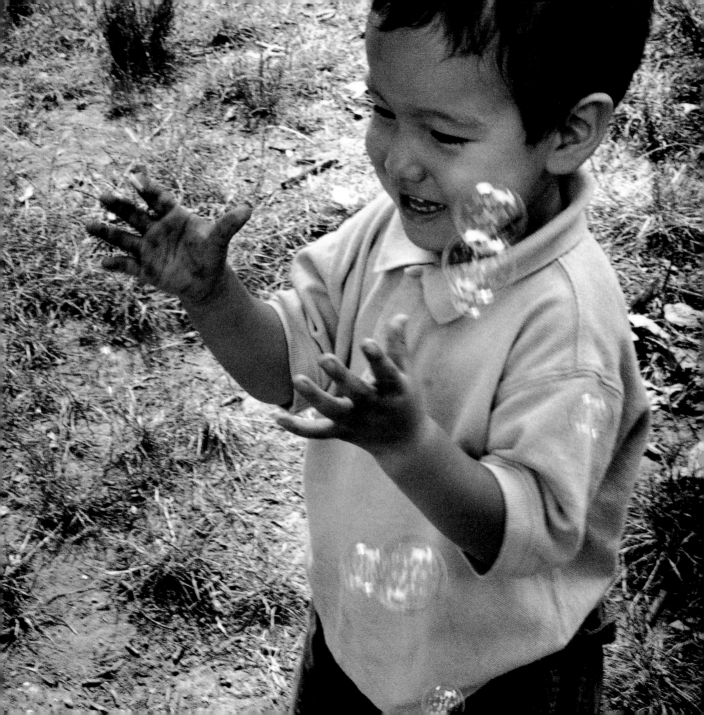

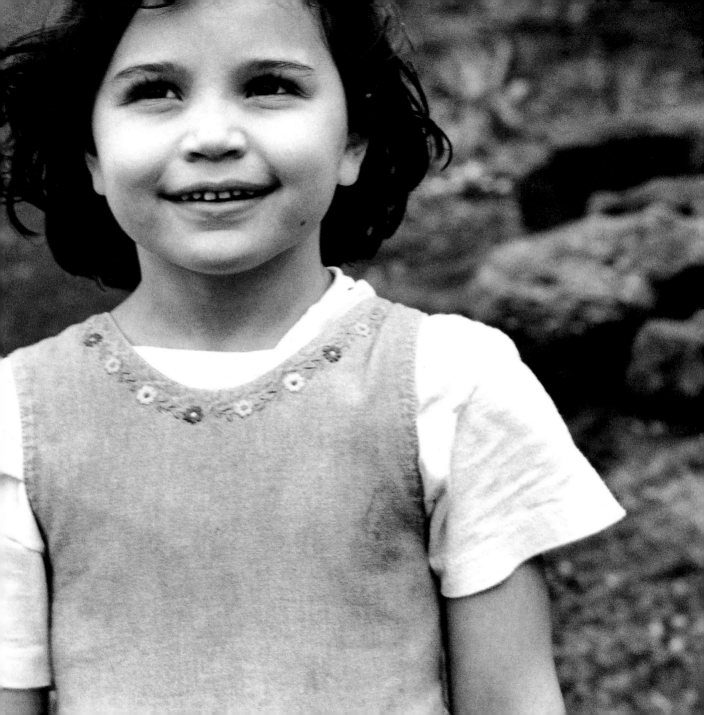

I'm Sleeping Beauty.
I'm not the baby.
I'm the girl.
I will turn into a swan.

RAVEN, AGE 3

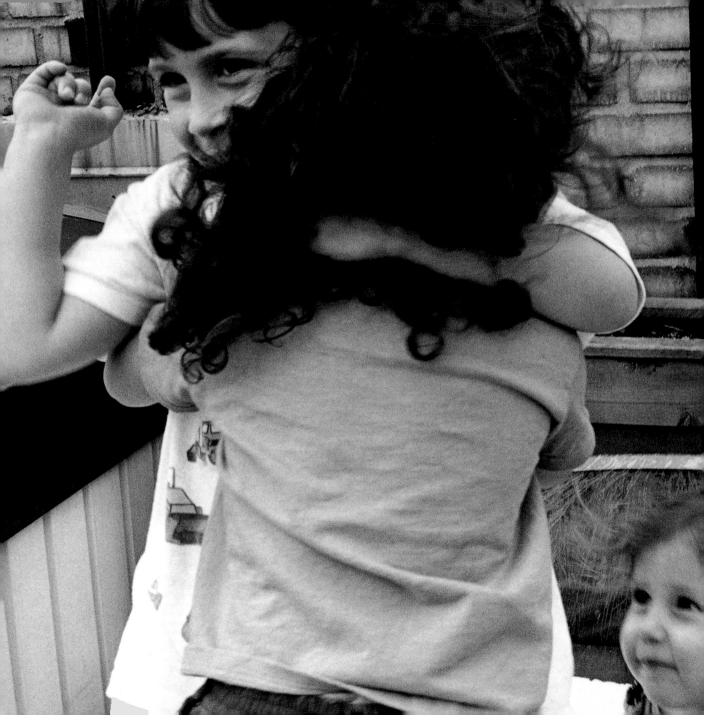

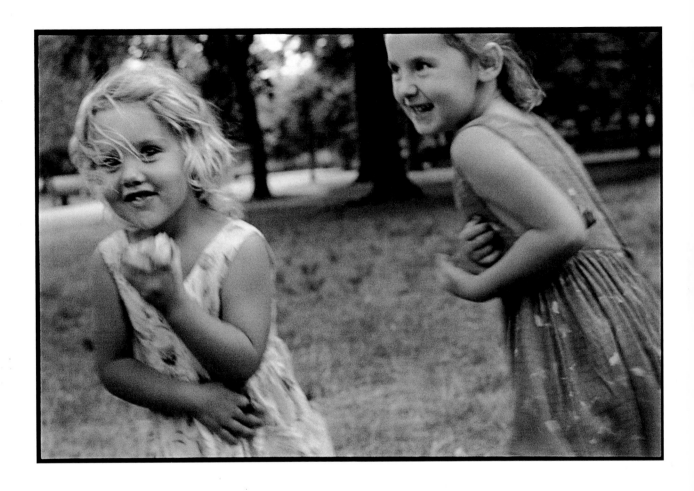

She's my best friend because
she's mine.

MEG, AGE 4

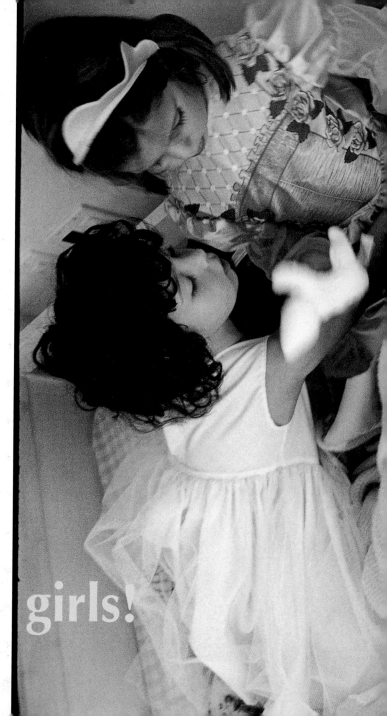

Mom, we're girls!

ANNABELLE, AGE 3

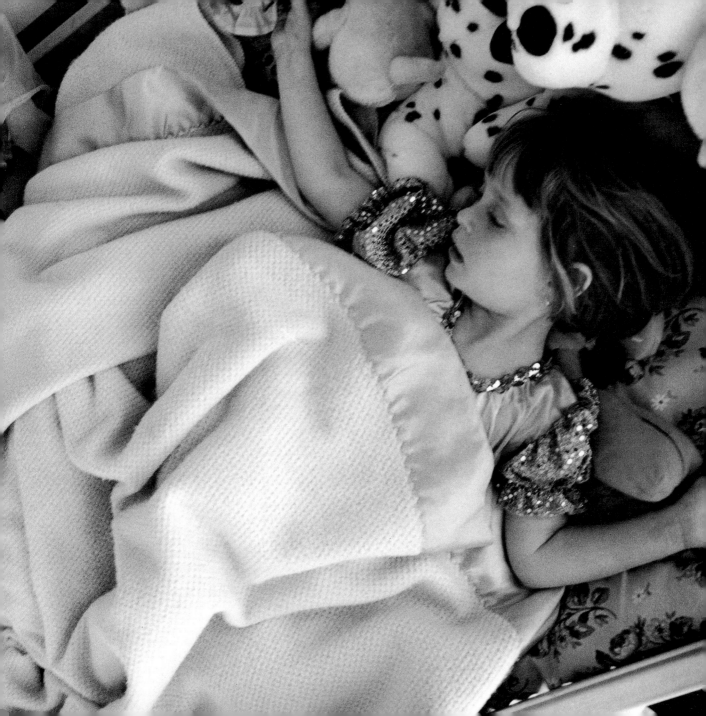

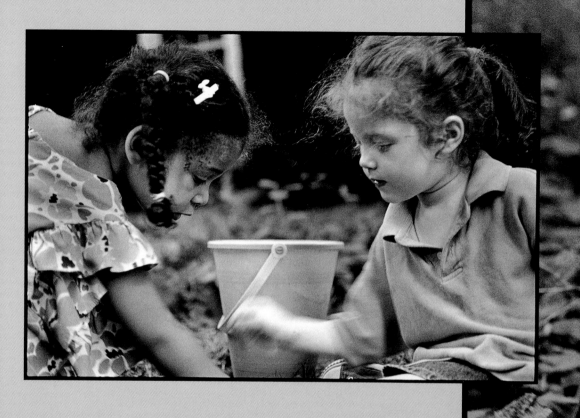

What's the meaning of life?
The earth was lonely so people were made.

DANIEL, AGE 9

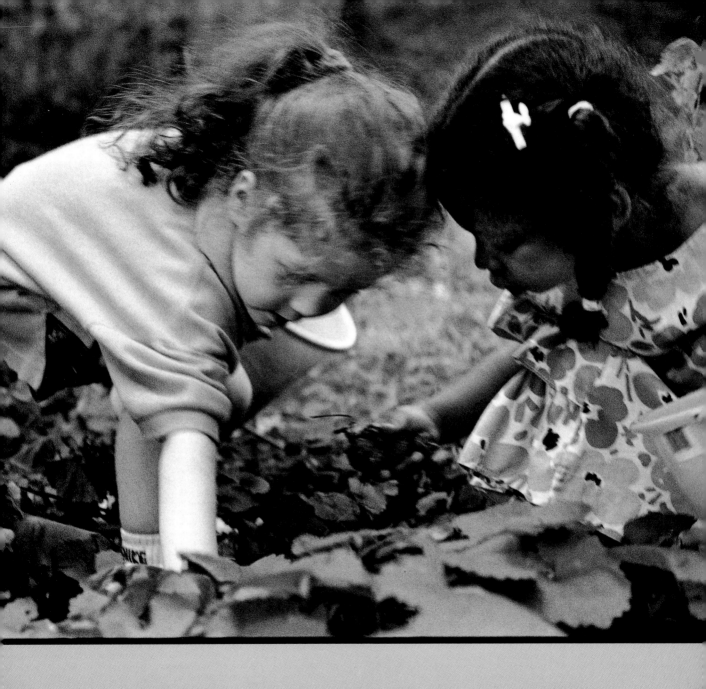

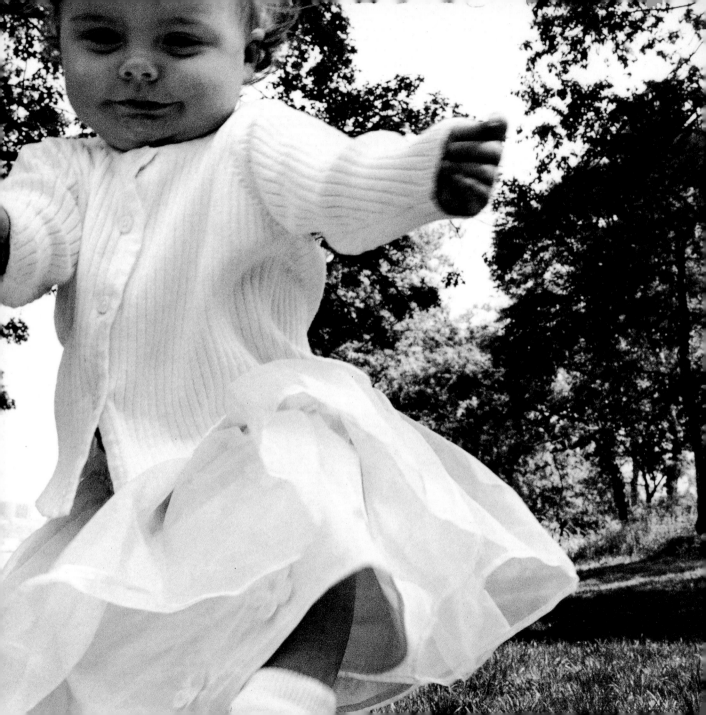

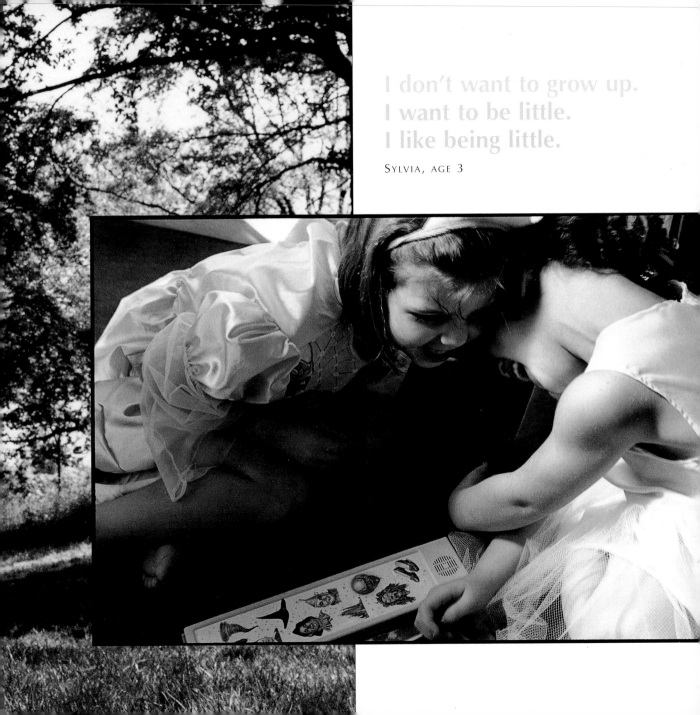

I don't want to grow up.
I want to be little.
I like being little.

SYLVIA, AGE 3

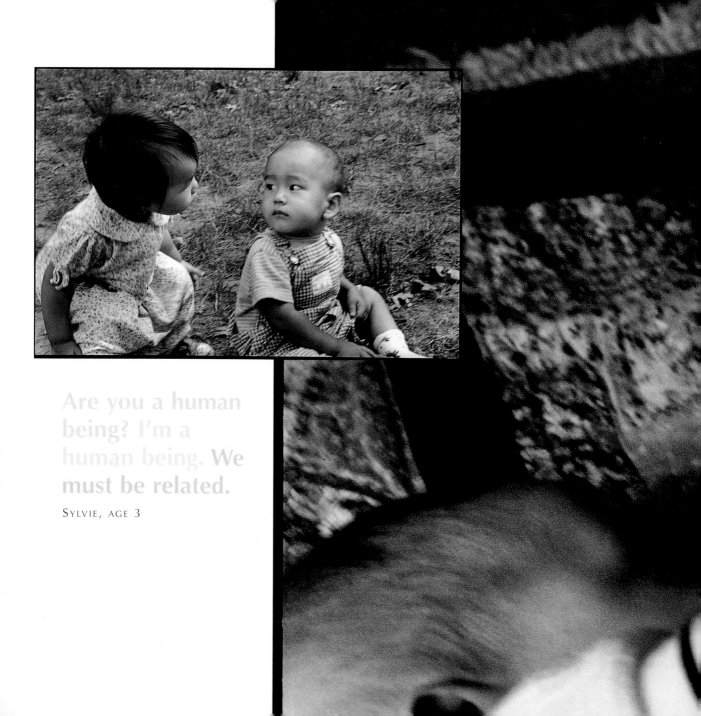

Are you a human
being? I'm a
human being. We
must be related.

Sylvie, age 3

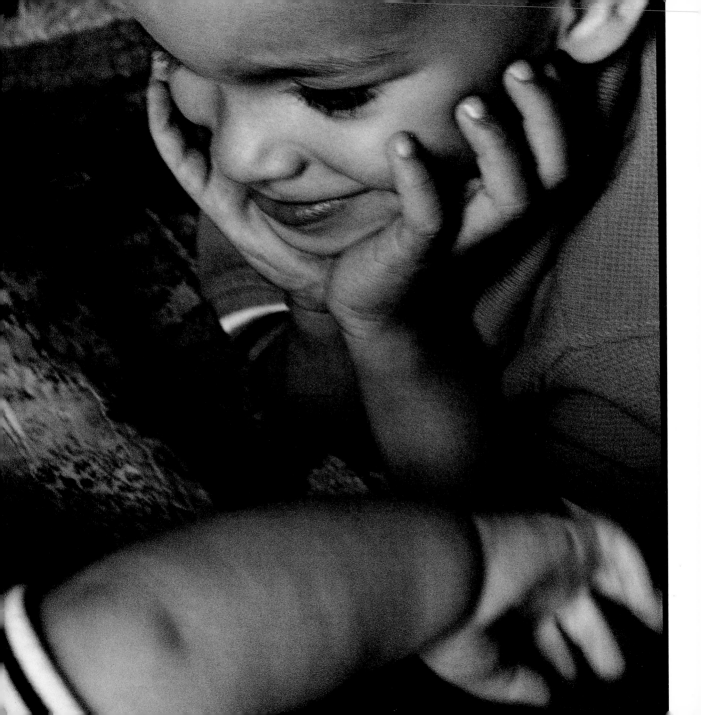

Once upon a time
there was a girl who said,
"the end."

SYLVIE, AGE 3

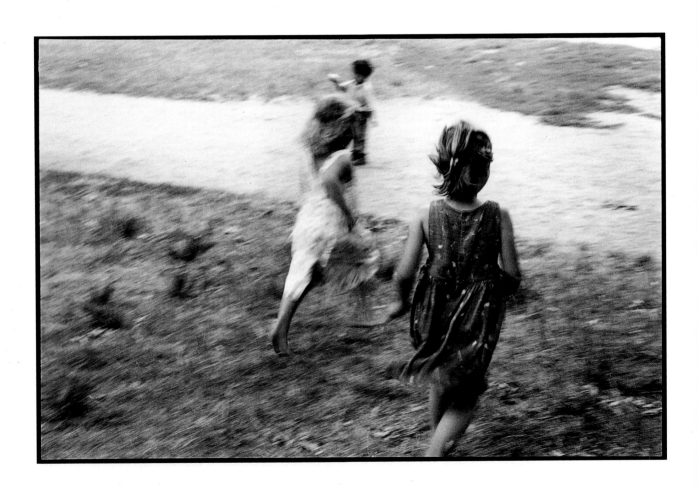

I AM GRATEFUL to the Key-Comis household for their enormous contribution to this project; Ned O'Gorman and the Ricky O'Gorman Library for allowing me into their sanctuary; John Littleton and the Marin Horizon School for your love of children and what they say to us. To Garr Lillard, Kent C. Thurston, and Laura Larson at Lab One, thank you for making these beautiful prints. Natasha Tabori Fried, I thank you for being such a wonderful editor; your kindness, warmth, and skill with language have been a great gift. To Gregory Wakabayashi and Hiro Clark Wakabayashi, also of Welcome, I am thankful for your wonderful eyes. I would like to express my gratitude to Lena Tabori, Welcome's publisher, for her genius and heart, and for believing in this project and seeing its potential with such immediacy. To Jackie Decter, thank you for your guidance and friendship. I would like to acknowledge Roger Straus, Jr., and Dorothea Straus for their unending support; Nina Straus for remembering; Roger Straus III for being my inspiration and helping me believe in my work. I would also like to thank Jacqueline Deval of Hearst Books for sharing her most precious gift, Jorden, and for making this book a reality. My deepest appreciation to all the wonderful families who helped make this book possible.

—L.S.

This book is dedicated to Ben Hammond.

Photography Credits

Cover: Elizabeth, age 3, Benjamin, age 1; page 1: Elizabeth, age 4, Elizabeth, age 4, Jessica, age 4; page 2-3: Lena, age 4, Isabelle, age 4, Karen, age 4; page 8-9: Elizabeth, age 5, Benjamin, age 3; page 10: Lena, age 5, Isabelle, age 5; Page 11: Iliade, age 3, Manon, age 4; page 12-13: Maurice, age 2, Raffaella, age 2; page 14: Anna, age 3; page 15: Jessica, age 5, Elizabeth, age 4, Elizabeth, age 4; page 16: Sylvie, age 3; page 16-17: Sophie, age 2, Lucy, age 3; page 18: Benjamin, age 3, Elizabeth, age 5; page 19: Tom, age 3; page 20: Rebecca, age 9, Quinn, age 10; page 21: Anna, age 3; page 22-23: Celestina, age 3; page 24: Aaron, age 4, Cynthia, age 6; page 25: Peter, age 7; page 26: Claire, age 8; page 28: Manon, age 4, Iliade, age 3; page 29: Amanda, age 2; page 30-31: Jorden, age 3, Alessandra, age 3; page 32: Nico, age 3; page 33: Maurice, age 2, Raffaella, age 2; page 34-35: Lena, age 5, Joseph, age 1, Isabelle, age 5; page 36-37: Tom, age 3, Susanna, age 3; page 38: Eve Wing Chi, age 3, Sylvia, age 1, Kojin, age 2; page 39: Jalel, age 3; page 40-41: Elizabeth, age 3, Benjamin, age 1; page 42: Benjamin, age 3; page 43: Elizabeth, age 4, Elizabeth, age 4, Jessica, age 5; page 45: Alexus, age 3; page 46: Elizabeth, age 5, Britany, age 5; page 47: Elizabeth, age 5, Britany, age 5; page 48: Avery, age 3; page 49: Sophie, age 3, Lucy, age 3; page 50-51: Annabelle, age 3; page 52: Ruby, age 2; page 53: Rebecca, age 9; page 54: Tyler, age 10, Danielle, age 9, Rebecca, age 9; page 55 (top): Danielle, age 9, Tyler, age 10, Rebecca, age 10, Peter, age 7, Perry, age 8; page 55 (bottom): Tyler, age 10, Rebecca, age 9, Danielle, age 9, Perry, age 8; page 56-57: Danielle, age 9, Rebecca, age 10, Tyler, age 10, Peter, age 7, Perry, age 8; page 58: Celestina, age 3; page 59: Celestina, age 3; page 60: Ana, age 5, Tori, age 5; page 61: Eve Wing Chi, age 3; page 62: Ariel, age 10, Emily, age 10; page 63: Jordan, age 4, Teddy, age 2; page 64: Sylvia, age 1; page 65: Kojin, age 2; page 66: Caitlin, age 6; page 68: Dylan, age 3, Avery, age 3, Kathleen, age 2; page 69: Iliade, age 3, Manon, age 4; page 70-71: Lena, age 3, Isabelle, age 3, Karen, age 3; page 72: Siobhan, age 3, Annabelle, age 3; page 73: Annabelle, age 3, Siobhan, age 3; page 74: Amanda, age 2; page 75: Isabelle, age 5, Lena, age 5; page 76: Sylvia, age 1, Kai, age 1; page 77: David, age 8 months, Jorden, age 3, page 79: Iliade, age 3, Manon, age 4; back cover: Elizabeth, age 5, Benjamin, age 3.

Compilation copyright © 2000 by Welcome Enterprises, Inc.

Photographs copyright © 2000 by Laura Straus

Produced by Welcome Enterprises, Inc.
Lena Tabori, Hiro Clark Wakabayashi, *Project Directors*
Natasha Tabori Fried, *Project Editor*
Gregory Wakabayashi, *Designer*

Library of Congress Cataloging-in-Publication Data

Straus, Laura.
 A child's world/ Laura Straus and the editors of Redbook.
 p.cm.
 ISBN 0-688-17536-8
 1. Photography of children. 2. Children—Portraits. I. Title.

TR681.C5.S68 2000
779'.25—dc21 99-045965

Printed in Singapore

First Edition

1 2 3 4 5 6 7 8 9 10

A Welcome Book

www.williammorrow.com
www.redbookmag.com